contents
& colophon

A Few of Them | Contemporary Photography

3 1907 00279 1464

Noovo Editions is an independent editorial and cultural project by María del Rosario González y Santeiro and Jorge Margolles Garrote with online and paper editions. Noovo seeks to be an aesthetic arbiter and cultural mediator at the juncture between fashion, photography and jewellery: a platform to show the highest level of creativity from around the world.

www.noovoeditions.com

Noovo paper editions are published by
The Pepin Press BV
P.O. Box 10349
1001 EH Amsterdam, The Netherlands
mail@pepinpress.com

www.pepinpress.com

Noovo volume 4: A Few of Them
ISBN 978 90 5496 166 6

Fashion editor
María del Rosario González y Santeiro

Photography editor
Jorge Margolles Garrote

Publisher
Pepin van Roojen

Copy editors
Ruth Styles & Femke van Eijk

This book is produced by The Pepin Press in Amsterdam and Singapore.

Printed and bound in Singapore

The fourth edition in our *Contemporary Portraits of Fashion, Photography and Jewellery* series, Noovo presents *A Few of Them*: an exceptional selection of international, contemporary photographers.

Noovo believes that photography is one of the most vibrant contemporary visual arts so we decided to find some of the best creators of contemporary photography and put them together in this book. These photographers all have certain characteristics in common: extraordinary creativity, perfect execution and a novel point of view that reflects their passion for what they do. Taking in a range of different disciplines – digital, portrait, architectural, landscape, fashion – here you will find photography as contemporary art. All of them use their camera as a creative tool to project fascinating thoughts and powerful images.

In addition to pictures, they were asked to provide text to accompany the images; in some cases they speak for themselves while in others, their life and works are described by someone else.

The result is a unique collection of inspired and inspiring profiles of people that create today's most imaginative photography.

photography

photographer

Aaron Hawks

http://www.mrhawks.com

Over the course of his 15 year career, Mr Hawks has seen his photography, film and installation work appear in publications such as Taschen Books and *Goliath* and *Juxtapoz* Magazine. His films have been shown around the world as well as local Californian theatres such as the Coppala, the Roxie and the Berkeley University Theatre. Mr Hawks has also appeared in a number of shows, and held his solo show at a shooting gallery that featured a hanging piano, several performance artists hanging in nets, an installation of one of his sets and mechanical trap devices that were remotely triggered by motion sensors. Currently working on new film projects, Mr Hawks is determined to continue to push his creative imagination to its limits.

photographer

Alessandro Bavari

http://www.alessandrobavari.com

Many things have been said about Sodom and Gomorrah but even now, nobody really knows anything. The only evidence for Sodom and Gomorrah's existence was handed down to us as part of the *Book of Genesis*. Some think the cities were submerged under the heavy waters of the Dead Sea, destroyed by a natural disaster as Pompeii was. In fact, according to geological studies, the area where they stood appears to be rich in sulphur, bitumen and oil as yet unexplored. When Lot's wife (Lot was the only inhabitant to believe in God and was therefore saved from Divine Wrath), overwhelmed by doubt and second thoughts, was transformed into a pillar of salt, one could imagine her to have been struck by a scorching gust of sulphur and ashes, as was the fate of the ancient Pompeians. So as not to have to face the colossus of archaeology, I decided to approach the subject by following a precise itinerary, imagining landscapes, portraits, environments and objects, and by following an almost identical path to the one that Italo Calvino took 30 years ago in *Le Città Invisibili* (Invisible Cities).

He wrote:
'All cities were invented; I have given each one a woman's name: Procopia, Zenobia, Chloe, Hypatia, Theora, Phyllis, etc (...). The book was created one piece at a time, at intervals which were sometimes lengthy (...). I keep a file on objects, a file on animals, one on individuals, one on historical figures and another on mythological heroes. I have a file on the four seasons and one on the five senses; in one I collect pages related to the cities and landscapes of my life and in another, imaginary cities, outside of space and time. I have the habit of taking photographs of everything wherever I go: human and animal matter, objects, landscapes and architecture. Materials that I have accumulated and catalogued of things photographed in museums and on the street, on trips outside Europe and on brief afternoon outings. Materials presented in this imaginary journey, the journey which launched me into the metaphor of these two forbidden and damned cities where people happily live in a total absence of morality, devoted to vice and lust, where every kind of sexual perversion is part of everyday life. In short, I have wanted the people of Sodom and Gomorrah to be happy, creative and imaginative up to the very day of the apocalypse in which God omnipotent, vexed by their excessive exuberance, decided to spread forevermore his immense black veil.'

Sodom and Gomorrah is an open-ended project, to which I will continue to add work. It is an ever expanding project, like Sodom and Gomorrah would be, had they survived the Divine Wrath: an irrational expansion, chaotic, exuberant and spontaneous, just like that of all modern cities.

Alessandro Bavari, The Angels of Lot

Alessandro Bavari, Prelude to Incest Between Monozygotic Twins

Alessandro Bavari, New Progenies: Portrait of a girl who looks at herself in a mirror

photographer

Arsen Savadov

http://www.savadov.com

Arsen Savadov was born in Kiev and graduated from the Kiev Art Institute in 1986. Since 1987, he has participated in major exhibitions throughout Europe and in the United States. Critics often describe his images as 'Neo-Baroque' because his elaborate compositions are reminiscent of 17th century Baroque painting. However, Savadov's compositions are entirely his own, distinguishable by the massive scale used to depict the colourful and fantastical worlds inhabited by his often frenzied subjects. The result is a social commentary that speaks to the loss of order and, to a certain extent, the loss of civilisation within contemporary society.

His work *Donbass-Chokolate* is a project that focuses on social research and should be seen as a response to the collapse of a symbolic order prevalent in post Communist societies, not as an apologia for artistic autonomy. In these images, diverse emblematic codes collide: nouveau-riche glamour with Ukrainian national mythology and neo-decadent eroticism with fragments of the grand style of Stalinist culture.

Arsen Savadov, Donbass-Chokolate, 1997 (from the Deepinsider project)

photographer

Atta Kim

http://www.attakim.com

Atta Kim was born in South Korea in 1956. His solo exhibition, *Atta Kim: ON-AIR*, was included in the Collateral Events of 53rd International Art Exhibition at La Biennale di Venezia in 2009. He also had solo exhibitions at the International Centre of Photography in New York in 2006, Leeum Samsung Museum of Art, Rodin Gallery in Seoul in 2008, the Society of Contemporary Photography in Kansas in 2001, the Nikon Salon in Tokyo in 1993, and has participated in numerous group exhibitions. These included shows at the National Museum of Contemporary Art in Korea in 2008, the Museum of Contemporary Photography in Chicago in 2007, Sotheby's Contemporary Art Asia: presenting 30 top Asian Artists in Miami in 2007, the Gwangju Biennale in 2004, the Australian Centre for Photography in Sydney in 2002, Haus der Kulturen der Welt in Berlin in 2002, the 25th Sao Paulo Biennale in 2002, the travelling exhibition Translated Acts: Performance and Body Art from East Asia in 2001, FotoFest in Houston in 2000, and the Odens Foto Triennale in Odens, Denmark in 2000. Atta Kim has received a number of awards including the 6th Hachonghyun Art Award, the 6th Donggang Photo Prize, the 4th Lee Myoung Dong Photo Prize, the 1st Hanam International Photo Prize and the Annual Artist's Prize of Photography Art Magazine in 1997. His work has been collected by several institutions, including the Microsoft Art Collection, the Museum of Fine Arts in Houston, the Los Angeles County Museum of Art, the National Museum of Contemporary Art in Seoul and the Samsung Museum of Modern Art in Seoul. Books of photography published by Atta Kim include *The Museum Project* from Aperture Foundation in 2005, *Atta Kim: ON-AIR* from ICP and Steidl in 2006. *Atta Kim: Water Does Not Soak in Rain* and *Atta Kim ON-AIR EIGHT-HOURS* are also available.

Atta Kim, On-Air Project, 2005 (from the New York series)

Atta Kim, On-Air Project, 2008 (from the Paris series)

Atta Kim, On-Air Project, 2008 (from the India series)

photographer

Bonnie Schiffman

http://www.bsphotos.com

'She caught a side of me that's more revealing than any other portraits I have. When I look at this shot, I understand why I actually enjoy being before Bonnie's camera' - Billy Cristal. Over the past three decades, Bonnie Schiffman has photographed hundreds of celebrities, from George Burns to Jerry Seinfeld, Julia Child to Joni Mitchell, and Muhammad Ali to Warren Buffet; all of which have appeared in major US and International magazines. The energy and spontaneity that Bonnie brings to her work is what gives rise to her unique images: we get a new and honest perspective of her subject. Laurie Kratochvil, former photo director of *Rolling Stone* and *In Style* magazine, said it best: 'Bonnie doesn't put herself in to the picture. She lets people do what they do so you don't get celebrity, you get the person.' Now Bonnie has archived a collection of portraits whose importance lies not only in her signature style of photography but also in their contribution to the chronicles of American cultural history.

Bonnie Schiffman, George Burn

Bonnie Schiffman, Roy Rodgers

Bonnie Schiffman, Angelyne Billboard Queen

photographer

Carsten Witte

http://www.carstenwitte.com

In many cultures, the butterfly is an allegory of eternity, a symbol of resurrection, a carrier of souls, the embodiment of goddesses. The delicate beauty of nature's unique creature blessed with wings touches the heart of every beholder. The desire to catch and conserve it for evermore is grounded in the fact that just when it is. At its peak of completion, the butterfly will be inevitably marked by its decay. In his latest work *A Beauty Collector*, Carsten Witte concentrates on precisely this cycle of beauty and transience. His flawless and perfect women seems to be captured, as if in a butterfly collection, forever preserved at the peak of their perfection. This is what moves the artist; the butterflies that are killed at the height of their beauty, perforated by a needle, like the models that are photographed to death until their beauty is fading and the photograph is left as the only evidence of its existence.

Carsten Witte, born in 1964, is the venerable high priest of beauty. As a little boy of three, he gazed slack-jawed, at passing beauties while walking at his mother's side. Many years later, having attended the Bielefeld school of photography, he worked as assistant for a number of renowned photographers and started his career as a freelancer with his own studio in 1989. Now he could finally dedicate himself exclusively to his perfect aesthetic; taking shots of beautiful female bodies, their eroticism and chasteness and the sensual play of shadow and light. Numerous fashion and lifestyle magazines engaged him and even in commercial images, Witte distinguished himself with the subtle and extremely reduced structures in his images. 'It's always faces that fascinate me and the mysterious purity of really beautiful people,' he has said. Since 1999, Witte has been focusing on photography as art. In 2003, he produced a series of timeless fantasies with female nudes who were always accompanied by a flower.

Witte: 'The basic idea of these juxtapositions of nudes and plants is very formal and purist. Form, colour and transience are reduced to a common denominator.' In 2000 Witte began a continuing series of works, entitled 'Gold'. Using secret tinctures and special lab techniques, his icons of beauty have been dressed in mysterious shimmering black-golden coats. The play of shadow and light, black and gold, gives the images complexity, depth and a subtle charm. Witte calls this phenomenon timeless absorption.

Carsten Witte's beauties are naked but never bare. They seem secure in the shadows. The interpretation of his works is left to the beholder but he subtly directs the perspective in his tableaux. One US magazine called him the David Lynch of fashion photography. His images are mystery plays; you never know exactly what is going on. Carsten Witte offers the parts but everyone has to solve the mystery himself.

Carsten Witte, Marie & Isey Gold, 1999

Carsten Witte, Sharing Smoke, 2004

Carsten Witte, Olessia Hand, 2004

Carsten Witte, Dasniya Quadrat, 1999

photographer

Daniel Linnet

http://www.linnetfoto.com

Daniel's ability to interpret a brief and add a certain creative flair to any assignment has seen him produce impressive images for MasterCard, Pfizer, OPSM, Country Energy, Bank West, Ford Performance Vehicles, St George Bank and *Top Gear Magazine* among many others. His work has also appeared in numerous international publications including *Graphics Photo Annual, the ACMP Australian Photographers Collection* and the *International PDN 2008 Photo Annual* and *Luerzer's Archive*.

Daniel began painting people and landscapes as a hobby but upon picking up a camera for reference shots, fell in love with the immediacy of the medium. 'I still use my painting skills in post production while grading my images. I enjoy the whole creative process from inception of the concept to the actual image capture, right through to the final treatment in post production.' An exceptional portraitist, Daniel captures a unique rawness and intimacy that has become his signature. In addition, his amazing technical ability has seen him become one of Australia's top automotive photographers. Daniel's treatment of light and his ability to create mood in high and low key scenarios is like no other.

Daniel served as the New South Wales Chairman of the Society of Advertising, Commercial and Media Photographers for three years and is now a master at the AIPP (Australian Institute of Professional Photography).

Daniel Linnet

Daniel Linnet

photographer

Denis Rouvre

http://www.rouvre.com

Denis Rouvre was born on 4th June, 1967 in Epinay-sur-Seine, France. He now lives and works in Bagnolet. Since 1992, Denis Rouvre has been taking quick portraits of celebrities, using as much time time as it takes to broadcast a news item. Call them stars of the moment or living myths, these models have a whole multiplicity of images, each conceived to suit their latest film. And each of these fleeting encounters poses a challenge: how to forget - and get them to forget - the character imprinted upon them. He rises to the challenge brilliantly. Rouvre engages his model in a game, which often turns into a fight - sometimes an all-out conflict - with a single goal in mind: to get the star to cast off his or her props and reinstate her or himself. 'The natural does not exist,' he explains. 'I photograph only one reality of a person, the moment that gets away from them and belongs to me alone. I need to make my model curious about an image of him or her that I might be able to produce.'

In his formal world, where the decor is reduced to a minimum, nothing exists beyond what his model can give him, even if it means seducing him or pushing him about until he takes a chance and heads into unfamiliar, risky territory. During these brief, no-holds-barred one-on-ones, he keeps track of the little things that happen, the surprising or anachronistic behaviour of the actor or producer in order to capture the fleeting moment when the celebrity loses control and makes a gesture belonging to someone else, or takes on an unsuspected expression or an unusual look - the unexpected fraction of a second that will make the photograph. Denis Rouvre's portraits do not tell a story. Instead they capture the visible detail of a spontaneous gesture, a sudden strangeness or a brief emotion.

Cécile Cazenave (translated from French by Gray Sutherland)

Denis Rouvre, Jean Paul Gaultier

Denis Rouvre, Tim Burton

Denis Rouvre, Lambert Wilson

Denis Rouvre, Florence Foresti

Denis Rouvre, Mof Chocolatier

photographer

Henry Horenstein

http://www.horenstein.com - http://www.pondpress.com

Henry Horenstein is a photographer, author and teacher. He has published more than thirty books, including some of the most widely used textbooks in colleges and art schools, such as *Black and White Photography: A Basic Manual,* which has sold over 700,000 copies in three editions. His latest textbook, *Photo One Digital,* will be published this autumn. Henry's monographs include *Show, Animalia, Close Relations, Humans,* and *Racing Days.* His work has been exhibited and widely collected by private and public collections such as the Museum of Fine Arts, Houston, the Museum of Fine Arts, Boston, the High Museum, Atlanta, the Smithsonian Museum of American Art, the Smithsonian Museum of American History, and the George Eastman House in Rochester. Henry studied history at the University of Chicago before becoming a photographer, and his work very much reflects his historical training. He is professor of photography at the Rhode Island School of Design.

Henry Horenstein, Remy Vicious

Henry Horenstein, Lie Down

Henry Horenstein, Catherine D´Lish and Dita Von Teese

photographer

Ione Rucquoi

http://www.ionerucquoi.com

Ione Rucquoi's visceral portraits capture a world of lost innocence and sexual awakening; exploring the disowned, unconscious aspects of the self and highlighting the primal instincts of the human character and the beast within. Rucquoi's affinity with Jung's psychological concept of 'The Shadow' allows her to move effortlessly among the symbolic and darker characteristics of the psyche. Driven by the motivation to make emotion visible through the physical, she explores fundamental elements of human existence and experience: birth, death, loss and change, and brings the hidden and taboo to the forefront.

Rucquoi's portraits are largely reflections of her own experience of being female, examining key rites of passage - coming of age, pregnancy, motherhood - and exploring the dichotomies inherent in these changes of state with frankness and humour. She frequently examines the historical female gender role, playfully mocking antiquated or misogynistic views. The finished pieces, which hint at Renaissance portraiture, take the form of photographs.

But for Rucquoi the process of composing the image through conceptual and physical layering is as important as the composition itself. Her works come into being through her individual relationship with the model, collecting and devising props and prostheses and directly painting the backdrop and model. She presents a bizarre and elegant melange of costume, colour and textile, where the human figure is juxtaposed with internal organs and animal forms. In the tradition of the surrealists, and in a society often governed by reason and inhibition, Rucquoi seeks to liberate uncensored fears, anxieties and obsessions; heightening awareness of the Shadow side. Her objective is to create work which serves as a vessel for emotion and elicits a subjective and personal response in the viewer. To meet the candid gaze of one of her models is to share in a quiet, private moment.

Ione Rucquoi, Silent Companion

Ione Rucquoi, Second Skin

Ione Rucquoi, Joan Rp

photographer

Jean-François Lepage

http://www.two-eyes.com

Jean-François Lepage began his photographic career in Paris in 1980, and held his first exhibition featuring portraits of the French actress Isabelle Adjani, in 1983. His early editorial work was featured in magazines such as *Marie Claire* and Condé Nast publications in Italy. He photographed many top models including Naomi Campbell, Gisele Bündchen, Hannelore Knuts, Lara Stone, Rianne Ten Haken and Kirsten Owen. Since 1980, Jean- François Lepage has shot campaigns for Comme des Garçons, Jil Sander, Lanvin, Masaki Matsushima, Nina Ricci and Shu Uemura, and his work has been published in magazines such as *Amica Italia, AnOther Magazine* (Man), *Common and Sense, Harper's Bazaar, Numero, Purple* and *Vogue*. In 2009, to celebrate its 20th anniversary, the French fashion association, ANDAM, gave Jean-François Lepage free rein to interpret the vision of the fashion award prize winners, Martin Margiela, Viktor & Rolf, Jeremy Scott and Gareth Pugh in the book *Moderns: 20 Years of Contemporary Fashion.*

Jean-François Lepage, Moonlight Zoo #6, 2006

Jean-Francois Lepage, The Other Side of the Dream #15, 2008

Jean-François Lepage, The Other Side of the Dream #11, 2008

MAN WITHOUT HEAD NUMBER 1

photographer

Jeff T. Alu

http://www.jeffalu.com

For me photography is an extension of some of my beliefs about life, such as the importance of constant searching. I've always been a seeker and I always will be a seeker. What am I seeking? Answers to nagging questions on the meaning of life? Am I trying to collect heavy, provocative data so that I can form some kind of philosophical treaty in my mind about the workings of the world around me? Partially, I suppose. Photography allows me to communicate the ways in which I see the world to others. Through it, I also discover new ways to see the world.

My shooting style is very spontaneous. Very rarely do I plan anything and it's the element of surprise and discovery that drives me forward. While I do enjoy travelling to obtain my shots, I also realise that there are many, many great shots waiting to happen right next to me. I just have to stop, breathe and observe to find them. I don't work with professional-grade cameras, and have never owned one. I use cheaper point and shoot cameras without any special lenses or filters. Rarely do I use a tripod. Photoshop is my second camera, and if I become Indiana Jones when I'm out shooting, I become a calm Zen master when working in Photoshop.

72

Jeff T. Alu, New York View

photographer

Juliane Eirich

http://julianeeirich.com

I was born and raised in Munich. When I was 14, my father gave me his old video camera and I made dozens of films with friends, mostly shooting at an abandoned airport in my hometown. It was a great time and I think that's where my love of capturing places came from. It might sound trivial but when my video camera broke, I decided to switch to photography. After school I did two internships in photography, one in Miami Beach with a fashion photographer and one in Munich with a photographer who focused on architecture and still life. I then studied for three years at the Fachakademie für Fotodesign (Academy for Photographic Design) in Munich. When I graduated in 2003, I moved to New York and then to Hawaii to work there and pursue my own projects. From 2007 until 2008, I studied visual communication at Hong-Ik University College of Design in Seoul for 18 months on a scholarship. When I finished, I returned to Munich and relocated to Berlin a year ago.

The main subject of my work is physical places. I am interested in the relationship between man-made environments and nature. This relationship can be of very different types: harmonic, complex, funny, surprising, shy and so on. Most of my work is done at night. Night photography is a slow and calm activity, but at the same time precise, which suits me and my way of working. I like the way I can focus at night, since there is less distraction both visually and acoustically than during the day. One of central aspects of my work is calmness. Our lives have sped up so much nowadays that I long for quiet more than ever.

Me Il-Sajin, the Korean title of my series, *Korea Diary*, literally translates as 'everyday one photo.' While living in Seoul, I gave myself the job of taking one photo every day. Instead of photographing fast city life, I chose to focus on quiet moments to compensate for this feeling of being constantly speeded up. The resulting diary is an inventory of poetic vignettes documenting contemporary life in South Korea. These photos are an encouragement to slow down, to appreciate the beauty of ordinary moments and look to the future with confidence.

Juliane Eirich, Supermarket

photographer

Magda Biernat

http://www.magdabiernat.com

Space, light, colour and the way elements relate to each other are the key components of my photographs. Guided by an interest in urbanism and habitation, I focus my work on the built environment and its influence on global societies. *Inhabited* is the result of my explorations into the world's private and public spaces, searching for differences and commonalities. Between 2007 and 2008, I spent a year travelling around the world taking photographs in 17 different countries: South Africa, Namibia, Kenya, India, Nepal, Thailand, Laos, Vietnam, Cambodia, Malaysia, Singapore, Australia, New Zealand, Taiwan, Mongolia and China. Throughout the journey I pointed my camera towards unusual architectural forms such as German colonial houses in Namibia or the concrete utopian pod village I found on the northeast coast of Taiwan. I wanted to use my photography to convey a sense of optimism and joy at being in the world. The core vision was to recognise the integrity of the way people live under different, in many cases extraordinary, conditions.

The world's cultures may be very different but when seen through a lens in terms of simple geometry, the complexities of cultural variation fall away. Here, I turn my camera onto the ordinary details of everyday life, looking past the complexities of race, religion or cultural differences and into the similarities of the mundane. I look into the quiet spaces where people sleep, rest or work. My first priority was to ex-amine the design and atmosphere of culturally diverse spaces and as I did so, I saw beyond diversity to a consistency in the ways in which we lead our lives. The buildings and interiors I've shot serve the same purpose no matter where they are found. Stripped of obvious cultural references and detached from their surroundings, they gain a kind of disorienting universality. The places are unoccupied but on closer inspection, items such as a crumpled pillow or a half empty bottle of water indicate a human presence. By carefully composing each frame and eliminating the people who otherwise would help to distinguish the place geographically, I gave the spaces anonymity. This anonymity forces the viewer to try and imagine who might live here, what they do, and most importantly, briefly switch places with the absent occupants and ask: could this be me?

Magda Biernat, Inhabited Project

Magda Biernat, Inhabited Project

Magda Biernat, Inhabited Project

photographer

Malena Mazza

http://www.malenamazza.com

The process goes like this. Each of Mazza's clicks becomes a photographic artwork. Each photo shows a somewhere in the world. Each print, a piece of art. Although Malena has worked in advertising, fashion and publishing for over 20 years, with her there is always something more. There is Malena. Malena with all her lightness, all her irony, her whole story. Her impressive professional history began after graduating from the Scuola di Cinema Televisione e Nuovi Media (School of Cinema, Television and New Media) in Milan with the role of first assistant director for Michelangelo Antonioni and the Taviani brothers. Her career continued with films on industrial production for companies such as Basile, Flou, Nivea, Illy Coffee, Nina Ricci, Monoprix, Garnier, commercials for brands such as Brooklyn, Swatch, Glen Grant and the creation of editorial work for newspapers, *la Repubblica, Interior, Vogue, Elle, Harper's Bazaar* and *Cosmopolitan* to name a few. She has also contributed to a number of photography books and has been a presence in individual and group exhibitions in galleries, including MiArt and the Venice Biennale.

There is a lot of work in Mazza's portfolio; it is so heavy that you almost want to take something to help the digestion. But all her work is fresh and light; indeed it sparkles just like her. Malena is bright, bubbly, laughs a lot and moves even more. Tall and slim, she runs on 12 inch heels from one set to another, makes a quick trip to New York, lands at Malpensa air-

port and is ready to head off to the club. Then she does it all over again. 'It's easy to find the energy to do all these things,' says Malena, 'because everything is beautiful. I always enjoy everything. I chose a beautiful location for photos for the exhibition opening on Thursday, I went to a lap dancing club and I enjoyed making a mistake. To get beyond the sets and art galleries takes talent, but it also means having the ability to enjoy making your mistakes.'

Malena Mazza, Donne e Cibo Special Project

Malena Mazza, Mother and Sons Special Project

photographer

Miao Xiaochun

http://www.miaoxiaochun.com

'The success of Miao Xiaochun's photographic works and 3-D animations is based on the naturalness that arises due to his embrace of cultures old and new. Past, present and future: in Miao Xiaochun's photo-projections, they are simultaneous and offer the viewer new opportunities to interpret them and become absorbed in the narrative and in the future.'
– Extract from *The Cosmos of Miao Xiaochun* by Beate Reifenscheid.

'Miao Xiaochun is an artist who isn't fazed by new technology for, and constantly confronts cultural pessimism. For over a decade, he has taken up the challenge of trying to understand the zero dimensions of numbers as a route to a new quality of experience. ... Miao Xiaochun stands for the radical reversal of the boring premise of the old forever contained in the new. He turns this perspective around, discovering the new in the old; a form of archaeology. In moving through the past, he shows us how the world someday might look. Unashamed, he parades our own art history before us and at the same time opens up our own present in a playful manner for a possible future of history that might already be its past. Only an artistic personality emerging from a culture rooted deeply in history such as that of China, could achieve something of this kind.

In the domain of China's new media art, Miao Xiaochun is considered to be one of the most representative and influential artists. His work *Microcosm* employed the latest three-dimensional computer technology to create montage images and virtual realities. The idiom 'looking up to the sky from the well' is used to describe a person with limited sight and knowledge who has difficulty in understanding the nature of things. Its opposite: 'looking down the well from the sky' means that if a person is put into a macro environment to examine micro things, he would also have difficulties in understanding the way things work. In these two maxims, the spectator's positions are changed but he encounters the same limits in understanding. In these idioms lies the significance of Miao Xiaochun's work. In his work, we can see the mutual reflection, the overlap between historical and modern images, Western aesthetics and Chinese aesthetics, classical painting and new media, humans and inanimate objects, war and peace, as well as violence and pacifism. In these processes, an abstract piece is created that both attracts and puzzles us.'
– Extract from *Miao Xiaochun: Microcosm Modern Allegory* by Huang Du.

Miao Xiaochun, The Last Judgement in Cyberspace: The Rear View

photographer

Michael Meyersfeld

http://www.meyersfeld.com

The son of a French-German father and South African mother, Michael Meyersfeld developed a fascination with photographic images at the age of six. He attended the King Edward High School in Johannesburg, after which he studied for a degree in commerce at the University of the Witwatersrand. He then joined his family's steel business. Later he entered the world of professional photography and straddles the line between commercial and fine art work.

Meyersfeld has won a number of international advertising awards, including Gold at the 2010 AOP Photography Awards. Currently preparing for his 14th exhibition, *Life Staged*, the works on show will incorporate three themes: conditioning, the changing role of woman and judgment.

Meyersfeld's images involve a performance, in which the sitter is only one element in the overall composition. The set, the sitter, the light and the styling are all part of the interplay, deliberately calculated to capture the tension inherent in the moment. The intention is to provoke, or evoke a reaction. All of the shots are ambiguously constructed, suggesting a narrative that resists resolution. There's no predicting the impact or the effect.

Michael Meyersfeld, Board Member

photographer

Michal Chelbin

http://www.michalchelbin.com

Michal Chelbin's work has been widely shown in solo and group exhibitions worldwide. Her critically acclaimed Monograph *Strangely Familiar: Acrobats, Athletes and other Travelling Troupes* was published by Aperture in 2008 and was awarded PDN's Photo Annual Book Award in 2009. Her next monograph entitled *Other Black Eye* was published in June 2010 by Twin Palms Publishers, with solo exhibitions in October 2010 at Andrea Meislin Gallery in New York and the M+B gallery in Los Angeles. Chelbin's work is part of many prestigious private and public collections including The John Paul Getty Museum, Los Angeles; The Jewish Museum, New York; The Norton Museum of Art, West Palm Beach; The Kadist Art Foundation, Paris; The Portland Art Museum and The Tel Aviv Museum of Art, Israel.

photographer

Namiko Kitaura

http://www.namikokitaura.com

Namiko Kitaura was born in Tokyo in 1977. She has worked as a freelance photographer in London and Tokyo and as an artist in residence at Fabrica, Benetton's research centre in Italy. She produces distinctive images with a strong, personal voice. The implied Romanticism within her works is both abstract and absolute. The images contemplate each other sensually, with a sense of graceful motion suspended in a non-temporal framework. She aims to visualise the almost invisible aspects of the human condition that lie below the physical and their juxtaposition: passion in depression, comfort in sadness, tranquillity in chaos and beauty in ugliness.

114

Namiko Kitaura

Namiko Kitaura

Namiko Kitaura

photographer

Noah Kalina

http://www.noahkalina.com

I am interested in visual tension. I like to think of my photographs as a way of learning about, and staying connected with, the world. At the same time, I'm interested in isolation; how we relate to the world around us and the subtle ways in which we feel disconnected. I tend to frame my subjects with their environments - broad landscapes, vast interiors, complex networks of geometric structures - both to bring out a sense of place and a sense of isolation. I see beauty in those relationships.

Noah Kalina

photographer

Polixeni Papapetrou

http://polixenipapapetrou.net

Polixeni Papapetrou was born in Melbourne, Australia where she still lives and works. She is a photographic artist who explores the relationship between history, contemporary culture and identity. Her subject matter has included Elvis Presley fans, Marilyn Monroe impersonators, bodybuilders and drag queens. Her interest in dressing up and the performance of identity is a consistent presence in her work.

Since 2002, Papapetrou has turned her focus to childhood. The main protagonists in her work have been her two children Olympia and Solomon as well as their friends. Papapetrou started making pictures about childhood partly because she wanted to communicate ideas about our culture that are best expressed through the symbol of the child, but more importantly, because she is fascinated by the world of childhood. Whether she is drawing upon ideas about the representation of childhood in 19th century photography, for example in *Dreamchild* (2003) and *Wonderland* (2004), exploring the power of dressing up, *Phantomwise* (2002), revisiting the experience of childhood in colonial Australia, *Haunted Country* (2006), or reflecting upon the lost freedom and regulated lives of children growing up in the world today, *Games of Consequence* (2008), she is illustrating her thoughts on the different facets of childhood and presenting a picture of a more knowing child.

In her most recent series, *Between Worlds*, 2009, the child subjects wear animal masks and perform dramas in Australian landscapes that appear to be the edge of a space or the end of an epoch. Her images convey some of the wonder that children might entertain in entering the animal kingdom. Through games of dress up and play, they transgress boundaries and blur the lines between fantasy and theatre, mythology and reality, children and adults, and animals and humans. What separates human beings from animals and children from adults? Though in a sense absurdist, she presents the children as animals because she sees parallels in their worlds. Animals enter our consciousness in mysterious ways and we look at them in order to understand ourselves and our emotional realm. For most of the history of philosophy, it is what we don't share with an animal that defines us as human. In a similar way, children are the 'other' that defines adulthood and for that reason, children pervade our consciousness, at times adorably and at times threateningly. By creating hybrids and blurring the lines of what we immediately recognise as child or animal, Papapetrou creates ambiguity around the space that children occupy in our cultural understanding. Within these ambiguities, she explores how children are imagined and how they might bestride the stage of art.

126

Polixeni Papapetrou, The Wanderer, 2009

Polixeni Papapetrou, The Reader, 2009

Polixeni Papapetrou, The Caretaker, 2009

photographer

Quentin Shih

http://www.quentinshih.com

Quentin Shih (34) is a Beijing-based photographer specialising in advertising, fashion and editorial work. He started taking pictures professionally in 1988 and is recognised for his enormous talent and high quality digital treatment. This has seen him create work for publications such as *Vogue*, *Esquire* and *Forbes*, and campaigns for major brands such as Siemens, Sony Ericsson, LG and McDonalds. He is also known for his work promoting Shanghai Masters tennis tournament in 2007, in which each player had a terracotta replica, emulating the famous Chinese soldiers. His work has had a major impact in his country since it is a good example of the process of modernisation that China, in particular Beijing, is enjoying. His work encompasses the world of fashion advertising and publishing, as well as personal pieces. *The Stranger in the Glass Box* is one of his most interesting projects. Commissioned to photograph models for Christian Dior, Quentin Shih came up with the idea of photographing them in glass boxes, which created two worlds in the same picture: one for the models and one for the Chinese people. The exhibition helped to create a dialogue between two continents and a dual means of expressing contemporary art and fashion.

132

photographer

Quinn Jacobson

http://studioq.com

Quinn Jacobson was born in America in 1964. He is an artist, photographer and professor. He has found great satisfaction in sharing information about the wet plate collodion process and other earlier photographic processes including daguerreotypes and calotypes. He has travelled extensively teaching the wet plate collodion process in Europe. He is the founder and director of the *'39-'89 Project: The First 50 Years of Photography*. He has exhibited his work in America and in Europe and is represented by the Centre Iris Gallery for Photography in Paris, France. He holds a BIS degree in Photography, Visual Art, and Communication from Weber State University, Ogden, Utah and an MFA in Photography from Goddard College, Plainfield, Vermont.

'When I was a young boy in the early 1970s, I travelled with my father to a low-income apartment complex he owned on Madison Avenue in Ogden, Utah. The people I met there lived on the fringes of society. They fascinated me then and have deeply affected me to this day.

As a fine artist, I use photography to explore my memories of the people I met on Madison Avenue and the questions I have about marginalised society. A renowned German photographer, August Sander, called people like them *Die Letzten Menschen*, 'The Last People.' They make me ask questions about identity, difference, memory and history.

In the old, forgotten photographic process I use, wet plate collodion, invented in 1851, photographs are made on glass and metal plates. The process is both difficult and somewhat dangerous to do. Each image is a handmade artefact and the process takes a lifetime to master. The technique was discarded in the 1880s when dry plates were invented.

Wet plate is the perfect syntax for my work. I use it as a metaphor as it relates to abandonment. The process was abandoned and forgotten, just as most marginalised people are forgotten by the mainstream. I also embrace it for its imperfections which echo our human imperfections.

Collodion's unique aesthetic gives a half-remembered dream quality evoking the feeling of memory. It's hauntingly beautiful and reveals deep, poignant qualities about the people I photograph. It also allows me to interact with the sitter in ways traditional photography doesn't. Because of the commitment, in terms of time, complexity and stubbornness, inherent in the process, I feel that the sitter co-creates the image with me. That process is very important to me. In the end, it's the co-creation that is the art. I consider the image, evidence or residue of that interaction.'

138

Quinn Jacobson, Portraits from Madison Avenue

Jacobson, Portraits from Madison Avenue

photographer

Ruadh Delone

http://www.delonefotografie.nl

As I child I drew all day long and I continued to do so until my late twenties. Then 'normal life' came along, together with my kids, and I lost my creative time. I still felt the need to create things and, one day, I picked up a camera. After discovering that a camera could draw a sketch in a thousandth of a second, I was thrilled. In late 2007, I got myself my first DSLR (digital, single-lens, reflex camera), a Pentax k10D and taught myself photoshopping skills.
All the images I take happen in the attic. That for me is the charm of it. No big things, no sets or great lights, no top-notch models or whatever; just me and my kids. All the post processing techniques I have learned are the result of exploring with the tools without any tutorials or help from others. I believe in a solitary process. I won't call it art, just the way I like to see things: sometimes a little dark, sometimes weird and sometimes with a bit of humour in it. I know for sure, I will be doing this for life.

Ruadh Delone, Marlene Dietrich

Ruadh Delone, Swallow

photographer

Sonia Sieff

http://www.soniasieff.com

Sonia Sieff is a French photographer, who mainly focuses on fashion, portraits and nudes.

She began her career on film sets working with directors of photography such as Mark Lee, Tetsuo Nagata and Denis Rouden, learning her skills and experimenting with lighting while directing a team. She was soon approached by magazines about shooting portraits for them.

During these photo shoots, she became close with the new generation of movie and music stars, including Natalie Portman, Lou Doillon, Sophie Auster, Gaspard Ulliel and Melvil Poupaud, and has followed their careers over the years. In the last few years, she concentrated more on fashion photography, collaborating with both French and international magazines, *L'Uomo Vogue*, *De l'Air* and *Le Monde* for example, and has also held exhibitions of her personal work.

photographer

Tomohide Ikeya

http://tomohide-ikeya.com

Tomohide Ikeya was born in Japan. While scuba diving, he met an underwater photographer and immediately decided that this was the job for him. Tomohide Ikeya started his career as a photographers' assistant in 2000. He has been working as a freelance photographer since 2002. He creates artwork around the theme of control. His first water series, *Wave*, was awarded the first prize in the Advertising category of the International Photography Awards, 2007. He was awarded second place in the Fine Art category at the Prix de Photographie Awards in Paris in 2010 and first place in the People category at the International Photography Awards in 2009 for *Breath*.

'We control all and we are all controlled. This is life, lived every day. We only realise the true value of the things in the moment of losing them, though they were always there. The things we can control and the things we cannot control. Desire, emotion, relationships to others and commitment to the Earth. We all control everything to meet our satisfaction. However, we are significantly controlled by everything around us. This is life. *Breath*, my latest work, focuses on breath - a vital activity for human beings which is controlled by us. All my photographs were taken under water. The air bubbles that appear in the water enable us to see breath with vivid clarity. Although we breathe unconsciously in our ordinary lives, it is not easy to breathe under water. Losing the air that we need for life, being enabled to breathe, being controlled by the water. We realise the true value of the things that always exist around us, in the moment of losing them. Some people accept its control and wait for the end to come without bidding defiance to it. Others are thirsty for life, struggling against the water and its control of them. This is the struggle for life, which appears clearly under water. *Breath* asks viewers the questions: what are the things you should know the value of, hold on to and control? And what is the most necessary thing for you?'

Tomohide Ikeya, Breath

Tomohide Ikeya, Breath

Tomohide Ikeya Breath

Tomohide Ikeya, Breath

photographer

Tricia Zigmund

http://www.triciazigmund.com

Turning pain into knowledge is a part of the human condition. Our desire for insight when faced with difficulty forces us to question both our perceptions of identity and our relationships with those around us. It is the exercising of and the investigation into these thoughts which, either when dealt with alone or with others, grants us relief in the midst of affliction. Using myself as a reference point, my images explore my personal circumstances and their direct repercussions on me. Rather than attempting to document my physical experiences as they occur, I have combined the shaping of tableaux with a performative approach. Using my body as a tool or a prop, what were once fleeting, unaccounted facets of personal experience are reconstructed within the mimetic nature of the photographic medium itself.

Intentionally deconstructing these experiences skews the normative process through which one deals with suffering, particularly as I reveal myself within these conditions to a viewer. The conscious awareness of a future audience is not, however, the prevailing aspect. I am immersed within a self-contained dialogue between the subject, photographer and performer: the nature of my affliction is broadened to encompass these new associations and interactions. What effect does this modification have, considering that it is a result of artistic intention? It is an approach that enables me to extend and scrutinise my trials: affliction is intended to withstand entropy and provide stability and growth. As for the viewer, despite incessant references to both body and experience, my identity reveals itself only from a distance. A sense of remoteness functions as a boundary and the viewer is impelled to find an insight using their own experiences. It is possible that in this reciprocation between me and the viewer that pain is expounded, knowledge is returned and our condition delineated beyond that of a single individual.

Tricia Zigmund, Exudation Poisoning

Tricia Zigmund, The Chromatic Quickening

PLAINFIELD PUBLIC LIBRARY

Plainfield, IL 60544

Tricia Zigmund, Streaming